Todi. November. Late afternoon.
Barely able to pick out the plum
trunks against the lemon leaves,
some of which gradually floated
to the ground. The ancient buildings,
ornamented with sculpted coats
of arms, receded into the dense fog.

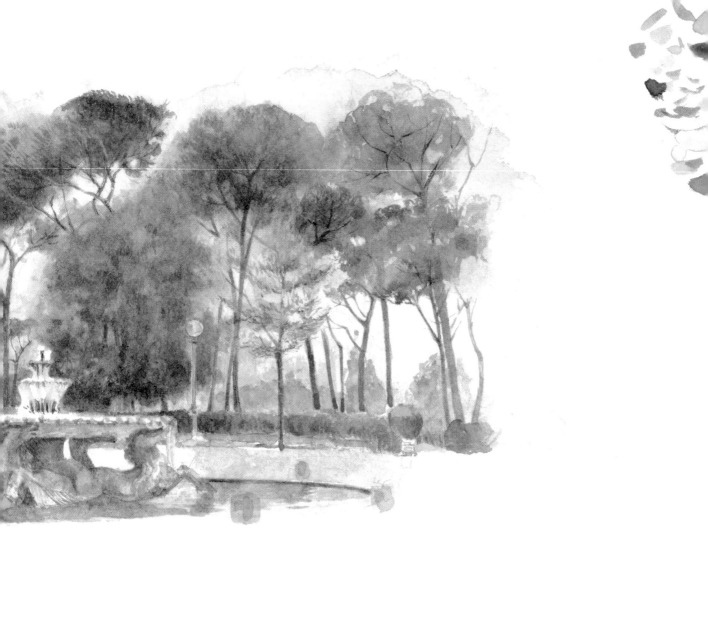

Villa Borghese. October. Late afternoon. Fiery reflections, ineffable shadows.

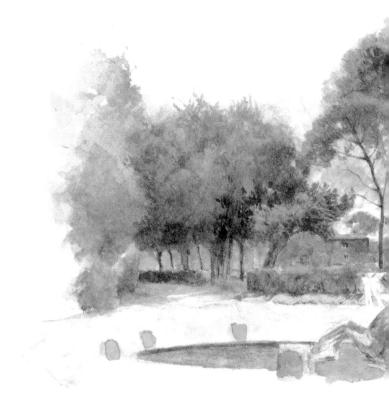

The air so thick with pink
light you could bite it.
Enveloped in color.

Roman winter skies. Dusk.

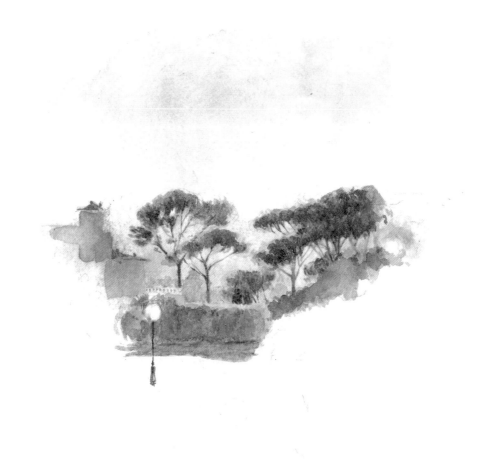

West edge of garden. Dying pink sky. Villa Medici.
St. Peter's in the distance.

Villa Borghese.

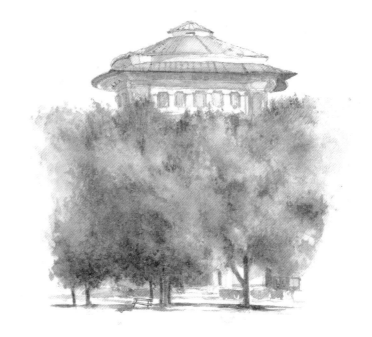

Lion around the corner from
the path to the Guardia.

Building across an expanse of ivory gravel.
Dull red tile roof. Muted green trees.
Scent of horses drifting over from the stables.

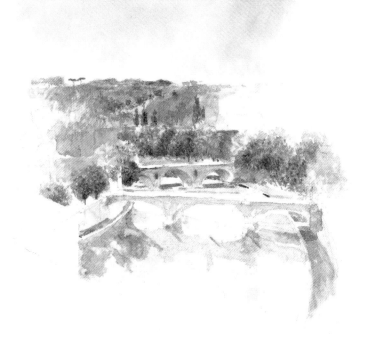

The Tiber, looking south from the roof of the Castel S. Angelo.
So much light reflecting in the intensely blue shadows.

Rome

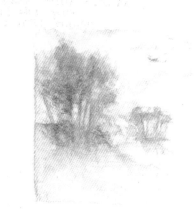

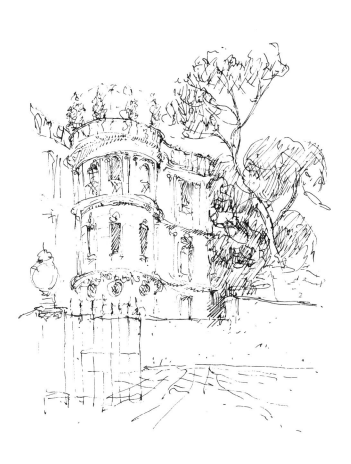

Elegant building behind the Acqua Paola.

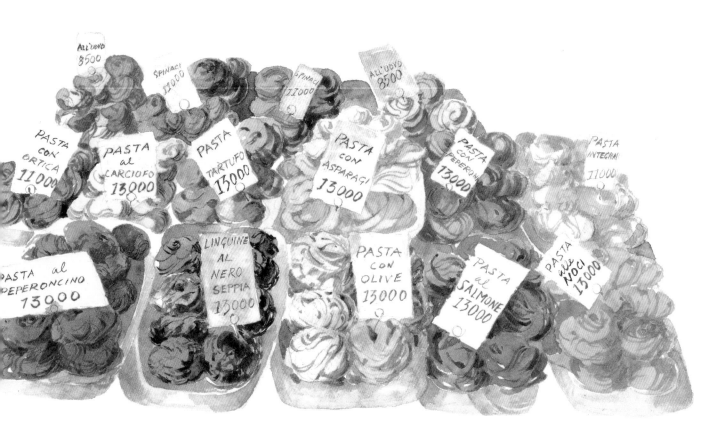

ALL'UOVO
8500

SPINACI
11000

SPINACI
11000

ALL'UOVO
8500

PASTA
CON
ORTICA
11000

PASTA
AL
CARCIOFO
13000

PASTA
al
TARTUFO
13000

PASTA
CON
ASPARAGI
13000

PASTA
CON
PEPERONI
13000

PASTA
INTEGRAI
11000

PASTA al
PEPERONCINO
13000

LINGUINE
AL
NERO
SEPPIA
13000

PASTA
CON
OLIVE
13000

PASTA
al
SALMONE
13000

PASTA
alle
NOCI
13000

Pasta shop window in Via Cola di Rienzo.

FUNGHI

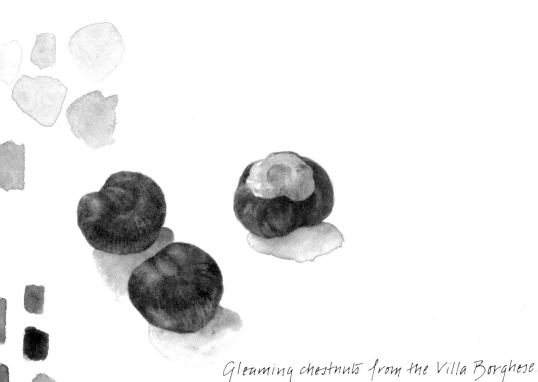

Gleaming chestnuts from the Villa Borghese.

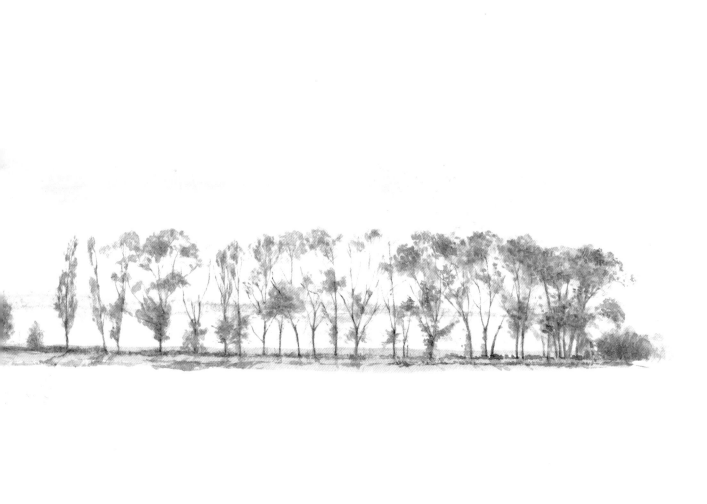

Continuing on from Trevignano to Anguillare. Sheep in the distance.

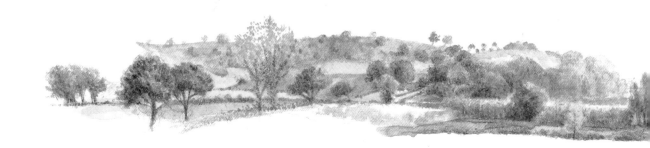

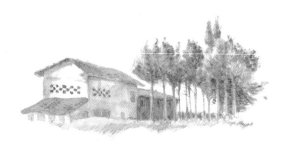

Dirt the color of gold.

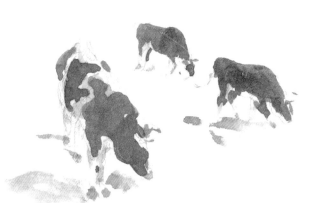

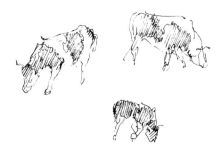

A few cows. Exquisite glittering light. November.

Lago di Bracciano. Trevignano.

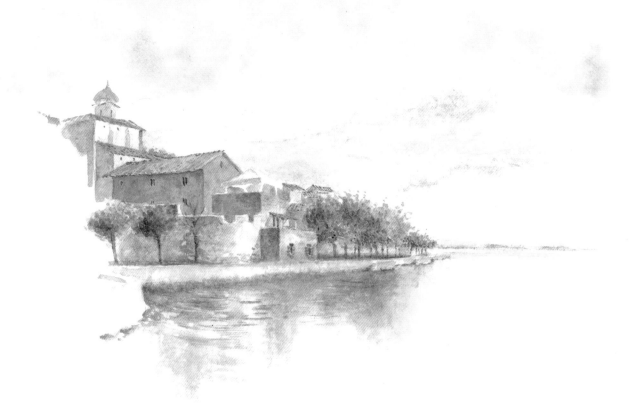

Smoke rising from distant shore. Smell of smoke. Trees turning.
Distant trees reddish. Tent on terrace catching light.
Cerulean sky. Cobalt blue, Venetian red clouds.

[note] stone: gray, mustardy moss

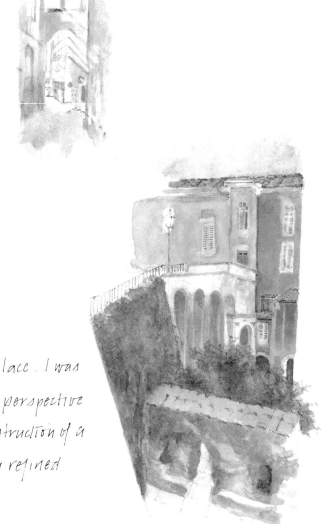

Behind the Pitti Palace. I was struck by the weird perspective and the chaotic construction of a stone wall in such a refined structure.

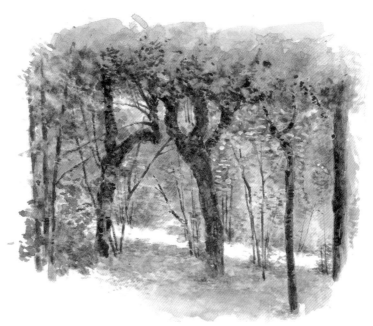

Boboli Gardens in October. The paths are so dark and dense
that the glimpses of turning leaves seem to catch fire.

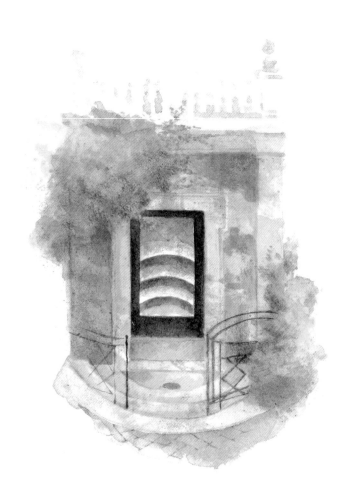

Doorway in Rome, across from the Acqua Paola in the Via G. Garibaldi.
Circular marble steps reflected in a glass door. Day after day of rain.

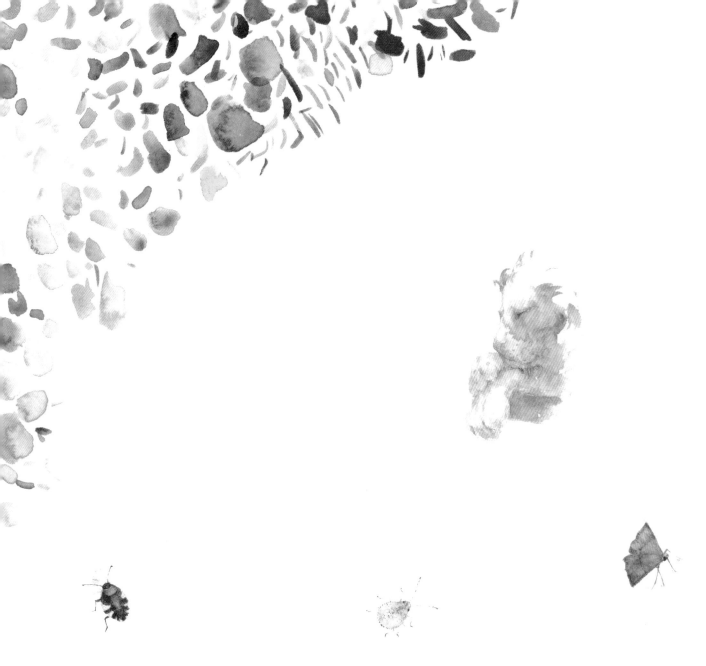

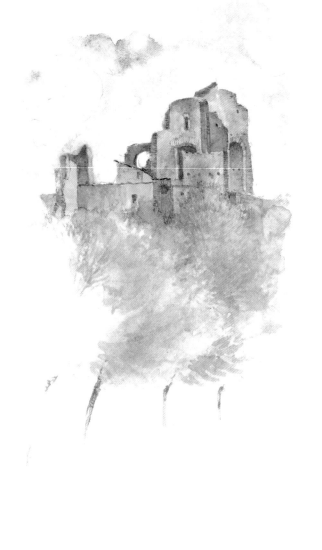

Behind the Forum complex

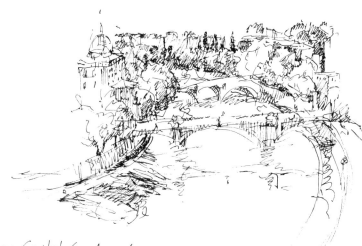

The Tiber, from Castel S. Angelo.

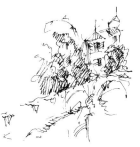

The Tiber

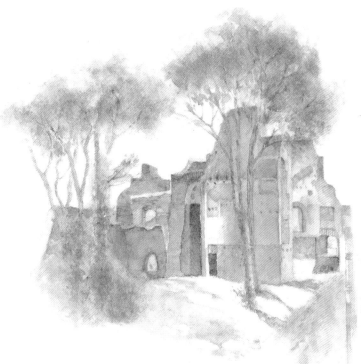

Palatine Hill, sky no color.

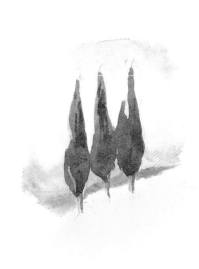

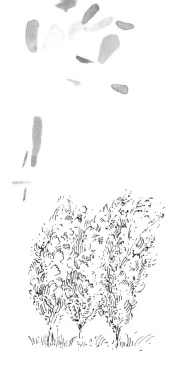

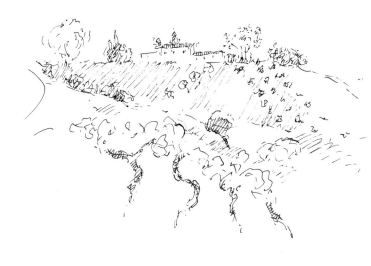

Cypresses in the extended
twilight of midsummer
There was enough light to
draw until 9:30 or so.

Rome

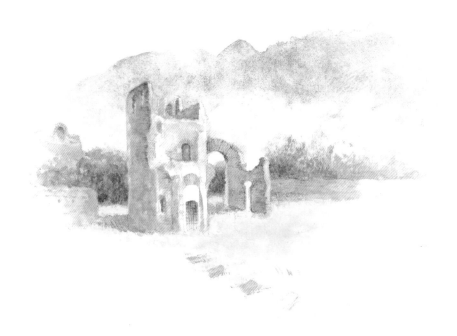

Circus Maxentius in the Via Appia Antica, across from the catacombs.
Early morning after a storm. The sky had been clear for only a few
moments; the gutters still swirled with rainwater.

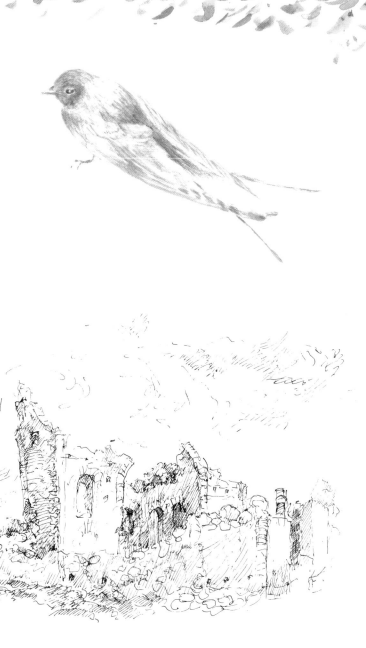

Ostia Antica

Walking along the edge of a pond, I
spotted a black clump clinging to the
side: a swallow. I fished it out, its
heart beating rapidly. We sat in the
sun for a while. It tried its wings,
but no lift. It perched on my left hand
as I drew with my right. Eventually,
after several tries, it was ready to go,
but it kept looking at me and remained
until I finished.

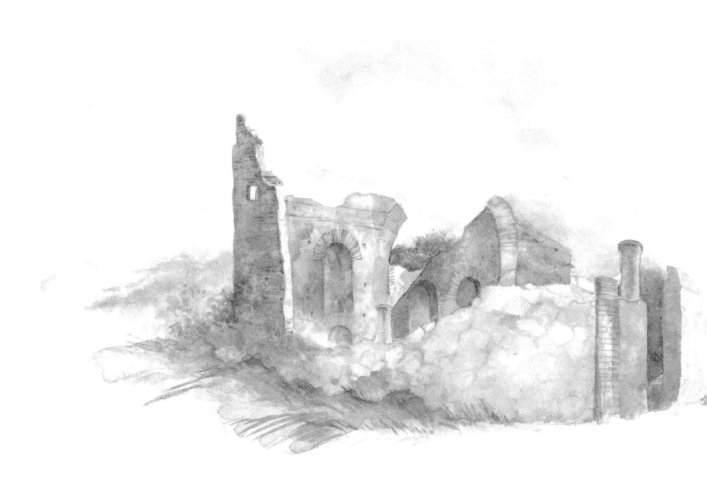

Via Appia Anticà

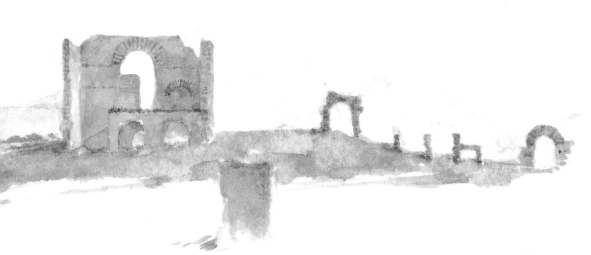

over the ancient stones, laid in Caesar's time, and turned into the field. The horses broke into a gallop, their riders shouting exuberantly.

Appia Antica. Glorious Sunday morning, immediately after a torrential
rainstorm. As I stood drawing, a group of young men on horseback clip-clopped

Villa Adriana

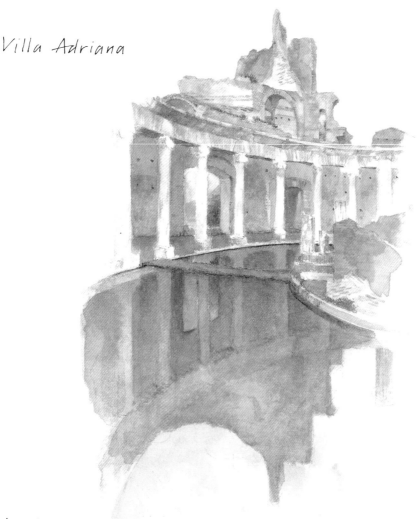

Teatro Maratimo.

I walked down a dark narrow stairway and was startled by a view of the sky
at my feet, which I then realized was a reflection in a circular pool holding a small island.

Rome

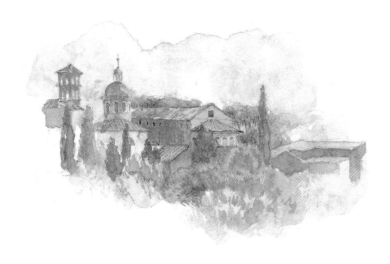

View to the south from the Palatine Hill.

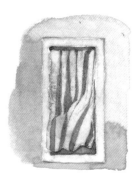

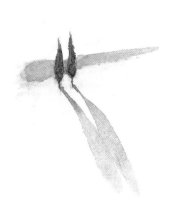

I drove into Arezzo about
5 p.m. and circled the "centro"
for over an hour, searching for
the appropriate 🅿 - parcheaggiare -
caught in the frantic traffic.
Glimpsed this house cum garage
out of the corner of my eye.

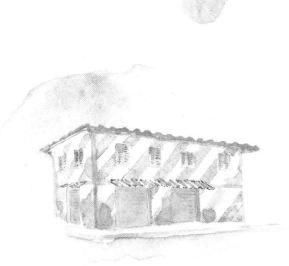

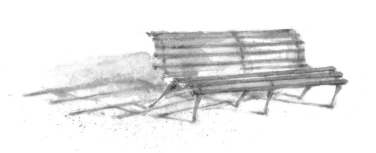

All the park benches are exceedingly low, with graceful wrought-iron legs.

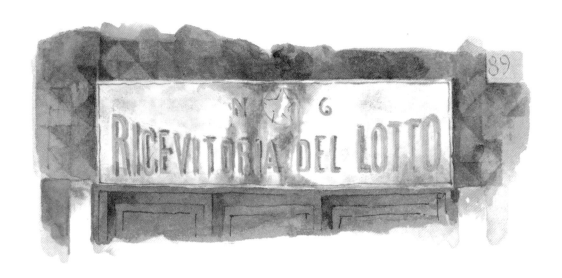

Shop in a little square off the Campo dei Fiori, closed for the siesta.

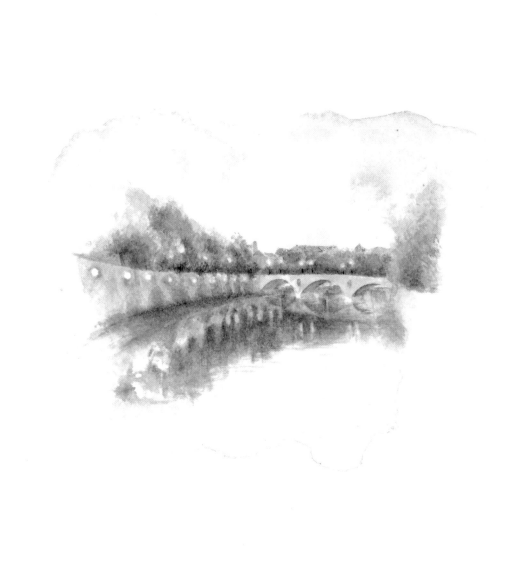

Rome, the Tiber

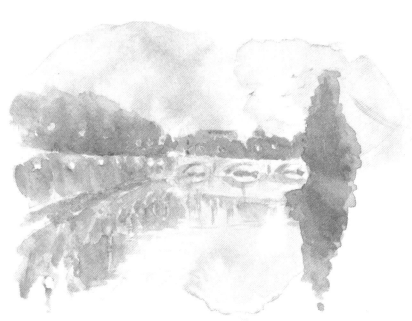

Every evening I walked along the river and became fascinated
by the luxuriance of color and the sensuality of the surfaces,
by the opacity and transparency of reflection and shadow.

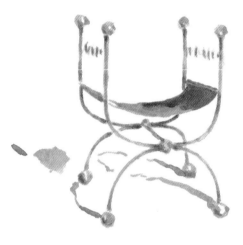

Eccentric little chair with
twists around the legs. Milan.

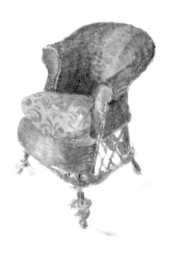

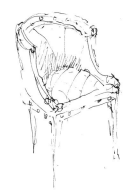

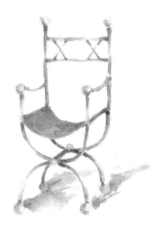

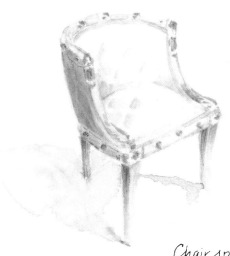

Chair spotted in the
window of an antique
dealer in the Via
Salaria, Rome.

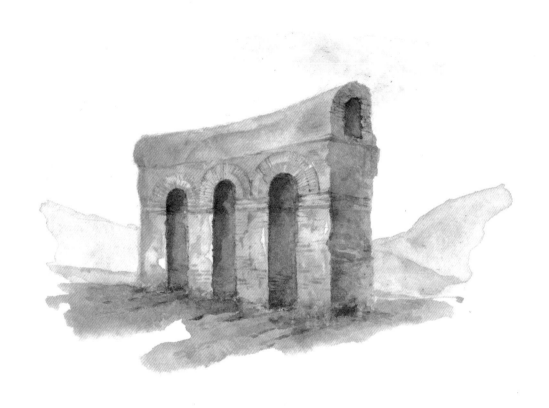

Isolated ruin of a Roman aqueduct in a plowed field east of
Tivoli. Very early hazy Sunday morning. Hills devoid of color.

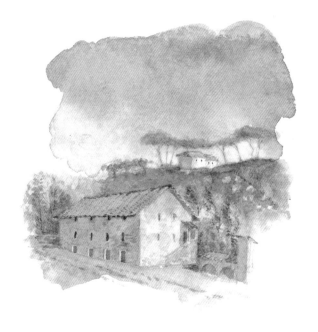

On the road to Assisi. October
Late afternoon. Truly purple
sky and low golden sunlight.

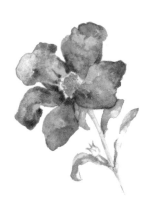

Rome

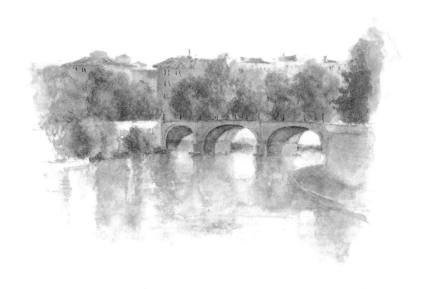

This is where Rome began to get under my skin.
The Tiber, about 4:30. Late October.

Florence

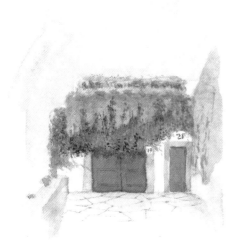

FRAGOLE

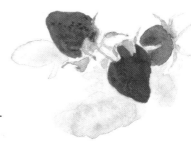

Wonderfully fragrant

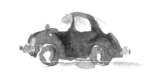

Sports cars with charm were
frustratingly rare, so I did a
study of a model that belonged
to a friend's son in Milan.

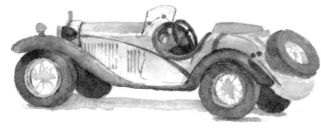

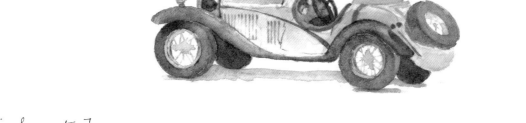

[color notes]
manganese blue, permanent magenta, viridian

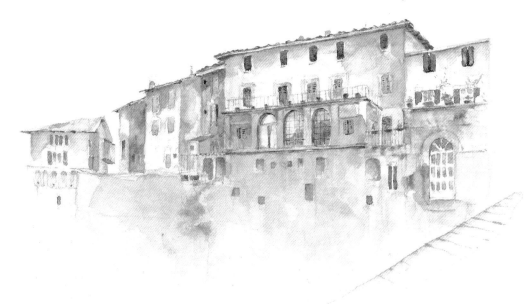

View from the bridge a few moments before dark in Umbertide, north of Perugia.

Distance marker.

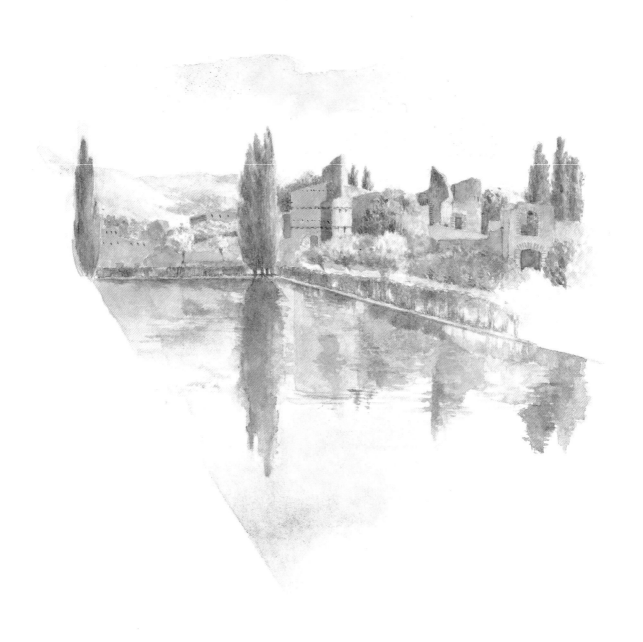

Villa Adriana

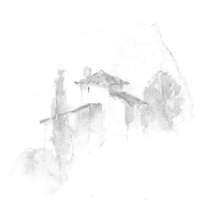

The next day, Saturday, everything was still and clear. Splendid rose greens, violet greens, olive-orange greens. The ruins of the massive complex, so well-built originally, still seem fresh.

Blustery day Turbulent whitecaps in the reflecting pool. The silvery leaves of the olive trees, agitated by the wind, flashed against the purple sky. The storm broke. In minutes I was soaked to the skin.

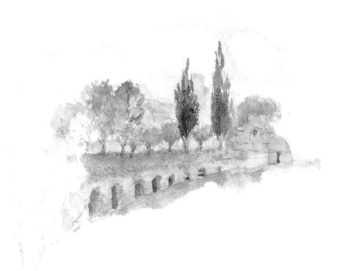

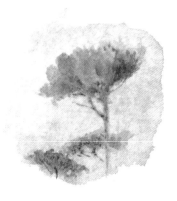

[color notes]
 terre verte, cobalt violet, new gamboge,
 permanent rose

Magnificent stormy day.
Thunder that lasted for
hours. Teeming rain
bouncing off the
pavement. Around 5 p.m.
I took a walk down the
Via Magnolia toward
the Pincio. Moment
of clearing just before
dark fell.

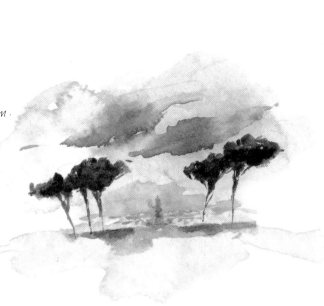

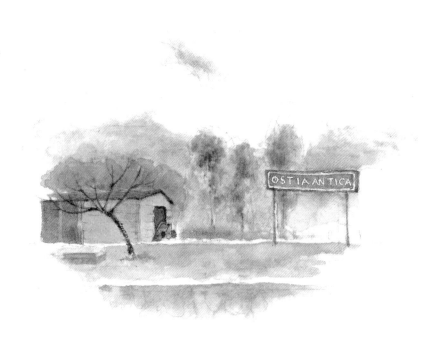

Waiting for the train to Rome at Ostia Antica.

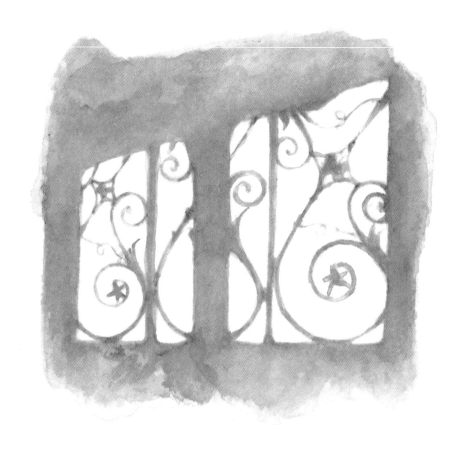

Castel S. Angelo. Originally a mausoleum, then a fortress, now a museum.

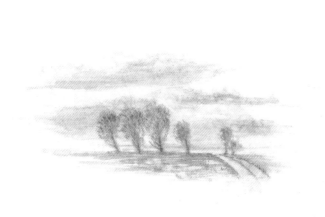

Rice paddy and canal outside Milan at sunset.
We were engulfed by rose light reflecting off the water.
The road evaporated in a shimmer.
After dinner, around midnight, we
drove back to Milan. Frogs croaking.
The silvery flickering of the poplar
leaves in the wind. Sculptural
quality of the landscape intensified
by the cool, even light of the moon.

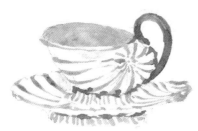

nautilus shell teacup on
a scallop shell-held by
Coral

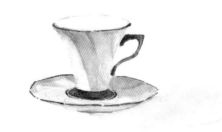

ESPRESSO

THÈ

MONTONE

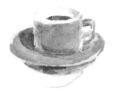

Cups with the emblems of
Sienese contrade, the
city districts.

DRAGO

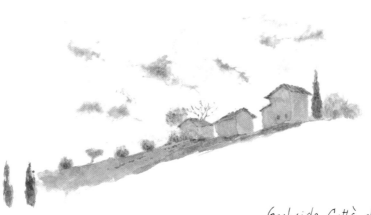

Outside Città di Castello,
looking east, 3 p.m. November.
Lemon sky, violet wisps. White
clouds on the horizon. Red soil.

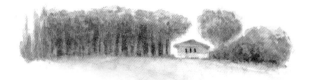

There's a villa southwest of Rignano peeking over
the edge of a gently swelling hill, bordered by a dense
copse of stone pines edged by cypresses.

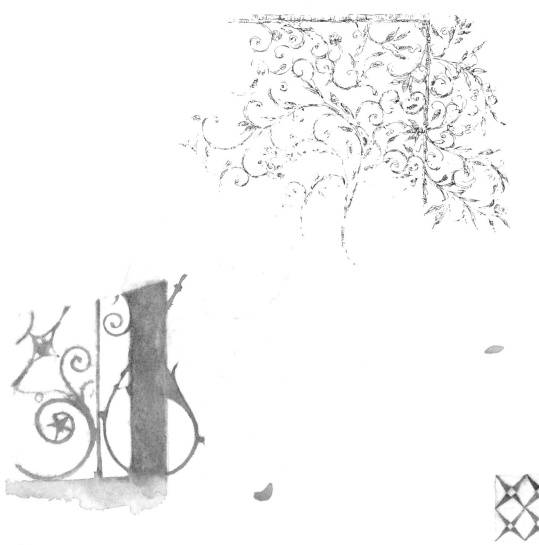

Shadow of decorative grillwork

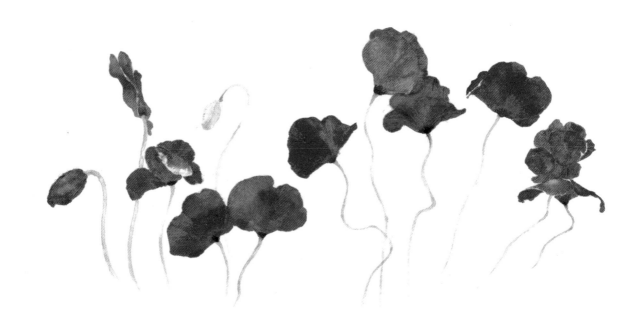

Poppy study from a chilly dawn. Fragrance of wood smoke. Cuckoos.

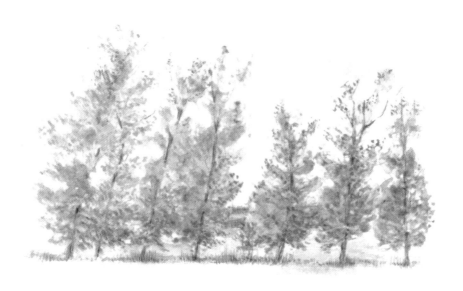

The combination of the abstract vertical rhythm of placement
and the sculptural detail of individual form may be
observed in any group of trees. A landscape to be savored.

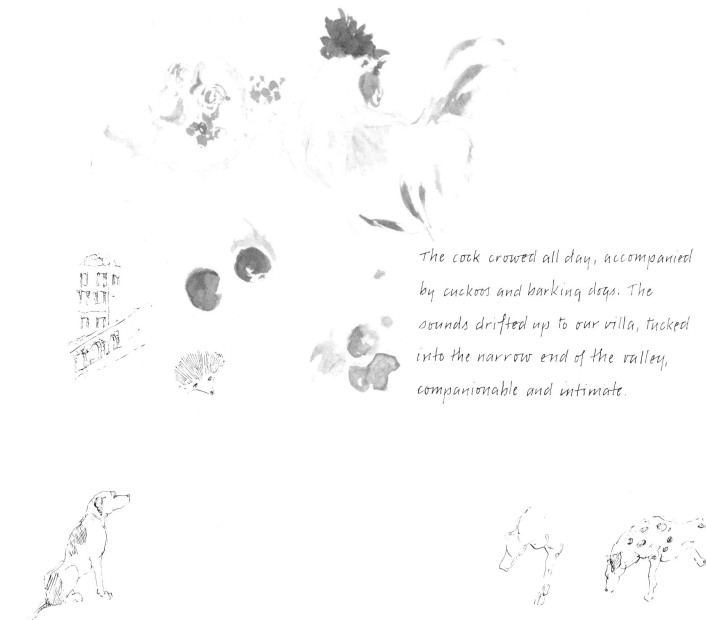

The cock crowed all day, accompanied
by cuckoos and barking dogs. The
sounds drifted up to our villa, tucked
into the narrow end of the valley,
companionable and intimate.

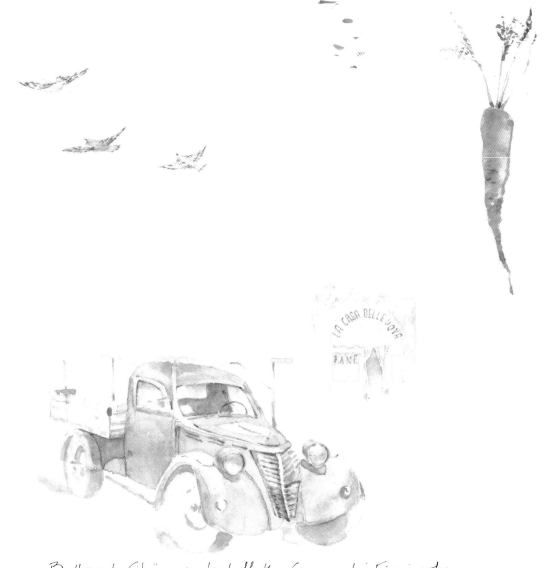

Battered Citröen parked off the Campo dei Fiori, where
a splendid open market is held every morning.

Rome

Chestnut casing from a
tree in the Villa Borghese.

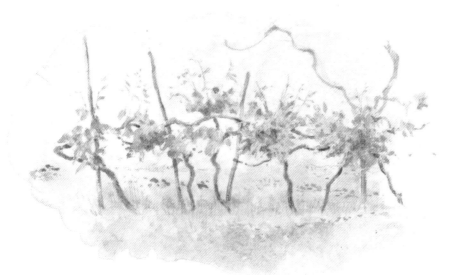

Grapevines on the grounds of the villa.

A bright orange splotch floating
on the surface of a turquoise blue
swimming pool that upon closer
inspection turned out to be a
butterfly. As it dried out after
being rescued, a cobalt green
shimmer spread over its
copper wings.

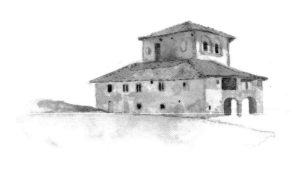

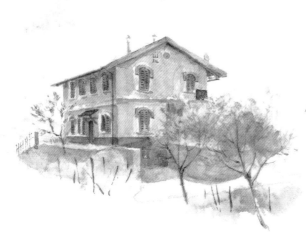

Intersection of Plan dell'Isola and
the road to Rignano.

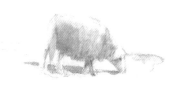

Sheep on the way from Siena to Volterra, beyond Colle di Valle d'Elsa, near twilight on a warm evening when the sky had a cool, blue violet haze. I cannot resist drawing sheep.

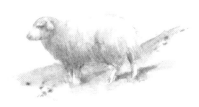

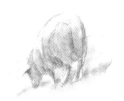

LE PÈCORE

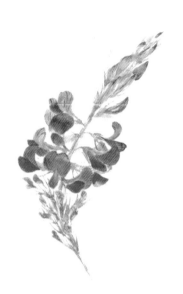

The light this morning was
startlingly bright. Brilliant
expanse of yellow, edged
with a great depth of
chartreuse poplars. Lots
of ring-necked pheasants,
plump and slow, their
iridescent plumage glinting
in the sun.

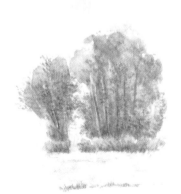

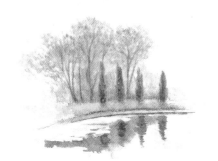

A pond filled with chartreuse frogs and mustard-yellow algae. On the edge of a valley southeast of Florence, where the slope flattens out just enough for the pond and a grape arbor. Enormous snails; huge dragon flies. Cypresses backed by locust trees in blossom; drooping clusters of fragrant white flowers, loud with the buzzing of gargantuan black bumblebees. Cuckoos sing all day and night.

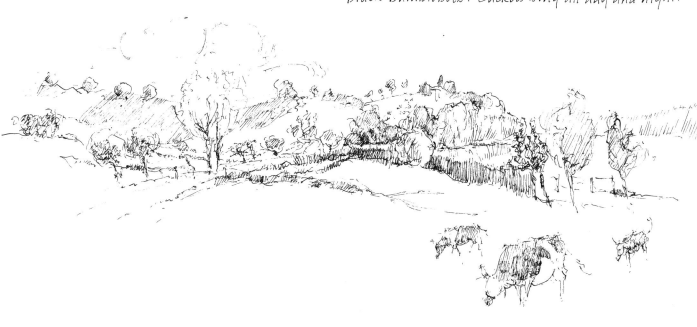

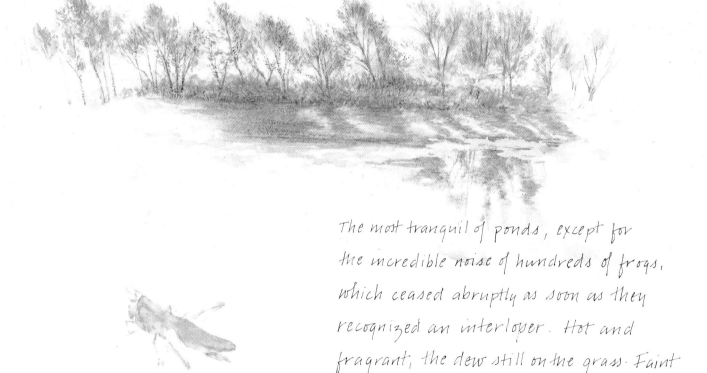

The most tranquil of ponds, except for
the incredible noise of hundreds of frogs,
which ceased abruptly as soon as they
recognized an interloper. Hot and
fragrant; the dew still on the grass. Faint
sizzling sound of the wind in the trees.
I love this place.

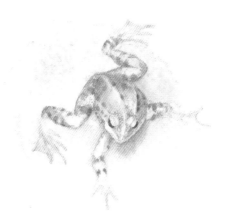

Frog lingering on
the water surface,
looking for lunch.

[color notes]
cadmium red, Winsor red,
rose madder genume.

PASSEMENTERIE

Tassel from L'Accademia

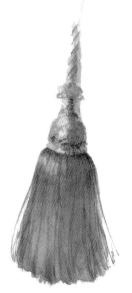

Oltr'arno. Noon.
Utterly brilliant light.

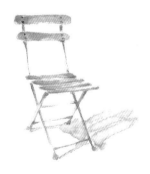

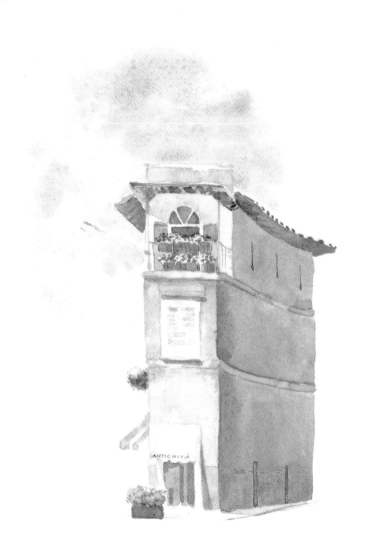

The only way to travel in Rome when a certain
wild urgency exerts itself.

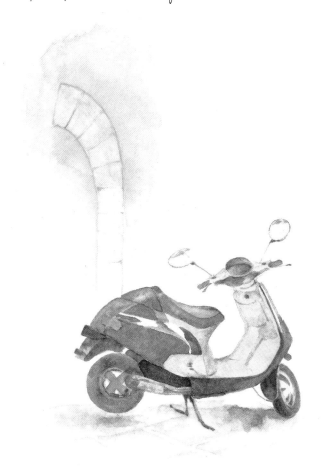

The remains of a sign painted over
an upholstery studio in the Via Margutta,
a street of art galleries and antique dealers.

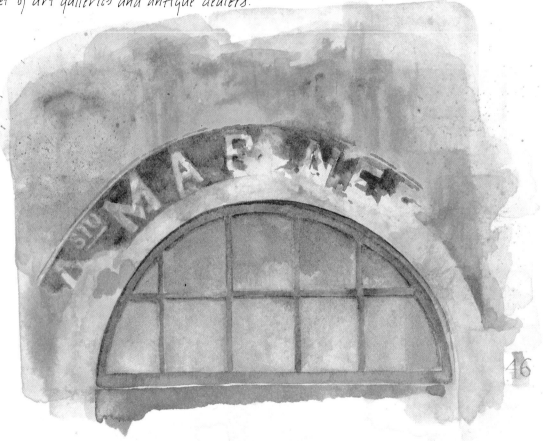

46

The buildings are washed with Roman reds and golds. Iron gates draped
with tangles of blossoming vines mark the entries to cool gardens.

Rome

Warm rainy day. The layers of deep ocher
and terra-cotta glowed against the gray sky.
Across the street, groves of olives.

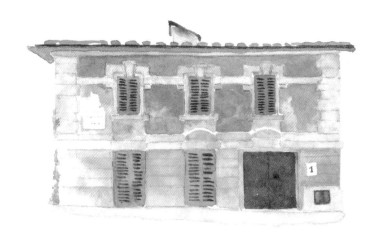

Tiles in a shop
window in the
Via Bocca di
Leone.

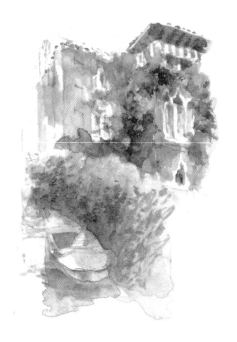

Venice. Around the corner
from the Guggenheim Collection.

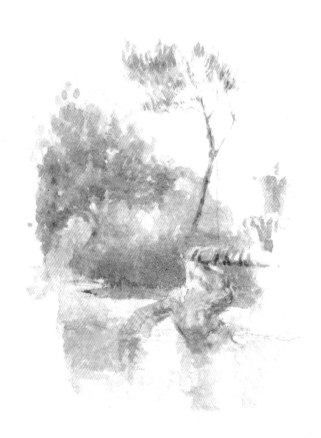

The horse fountain of the Villa
Borghese shone with pink reflected
light from the setting sun, against
the black greens of the trees.

Window within a window,
partially plastered over.

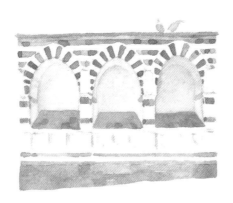

A fragment of S. Maria Novella: with pigeons,
who land with a plop and make a pearly sound.

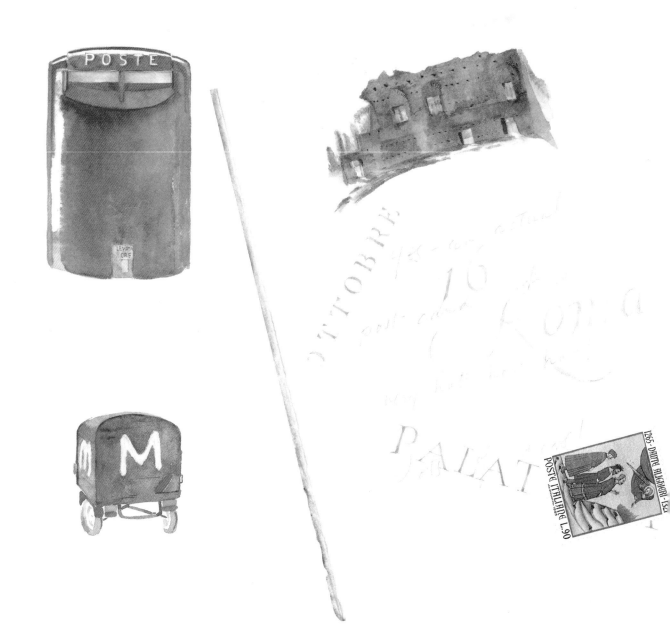

Rome

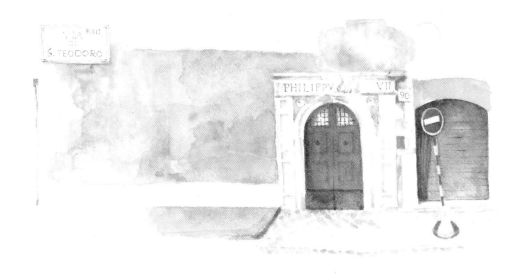

Via di S. Teodoro and Via de Cerche, around the corner
from the Boca de Verità and across from the Circus Maximus.

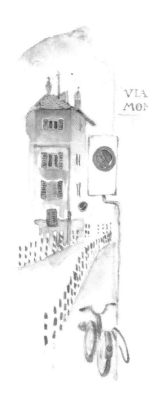

The houses that line the Erta
dell' Canina, which leads to San
Miniato, are painted deep gold
ocher, and have, almost
exclusively, bluish green doors.

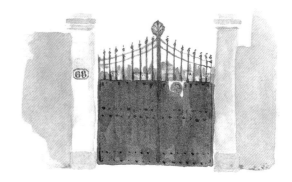

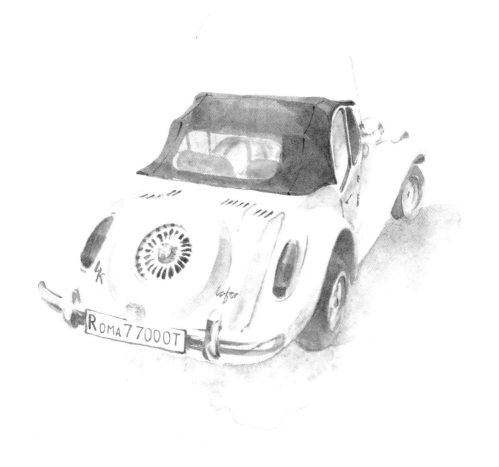

A Lafer – wider than an MG, with a more sloped back.

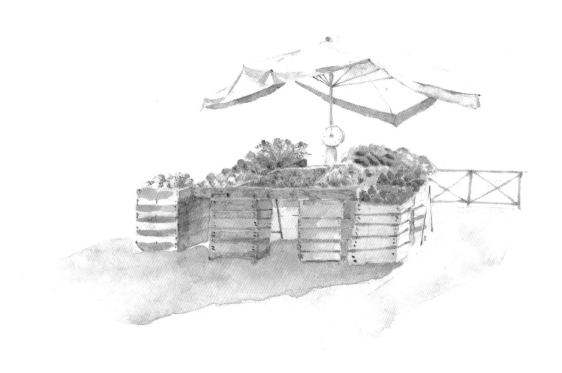

Quiet October afternoon in Rome. Streets deserted. Everyone at lunch.

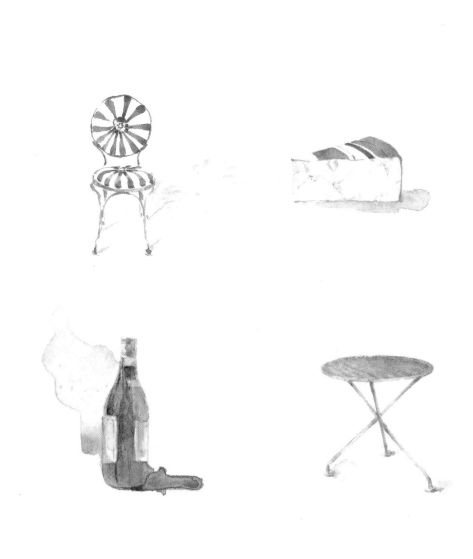

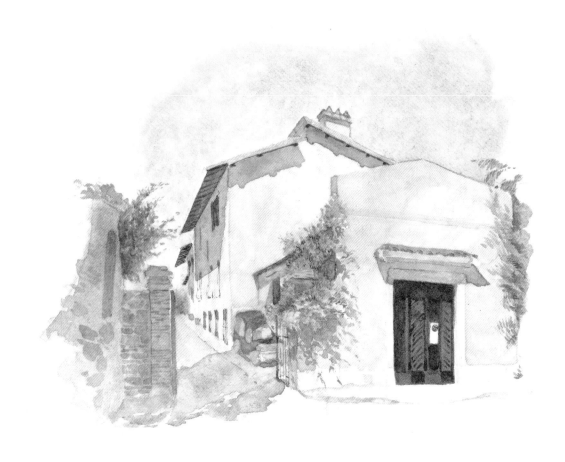

Wonderful street behind the Belvedere, lined with pink
houses and earth green groves of olives. A Saint Bernard
napped in the shade of the garden.

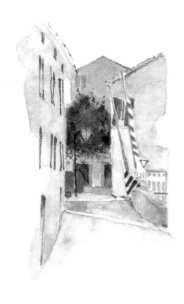

Glimpse down a
small street in
Umbertide at sunset.

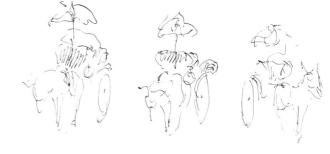

EMPORIO

FERRAMENTA E COLORI

Anquillara, a town on the south shore of Lago di Bracciano.

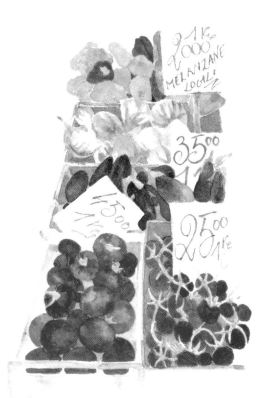

MELANZANE
LOCALI

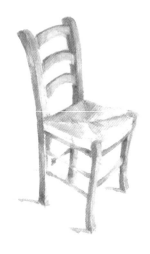

Boots are worn
in the garden to
protect against
stinging nettles
and snakes.

A handmade chair, every
curve gracefully nuanced,
tinted with Winsor &
Newton gouache.

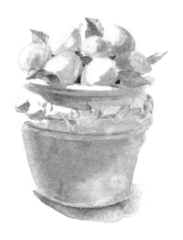

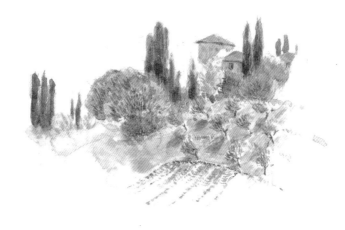

Looking to the west, from the grape arbor
toward olive groves and vineyards.

A scarab beetle I just saw lighting on an iris,
bending the stalk of the blossom with its weight;
it then landed on my foot, crawled under my
sandal, and burrowed into the loose gravel.

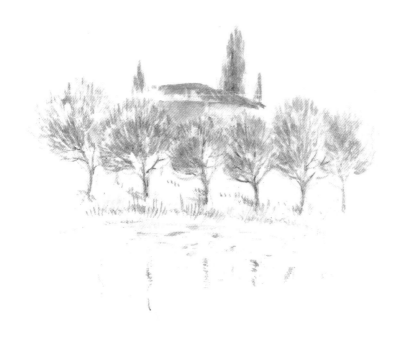

Noon at the frog pond. Very hot. The sky had no
color, the shadows were voids. I sat looking east, in
the shade of a grape arbor, to work.

At the Villa

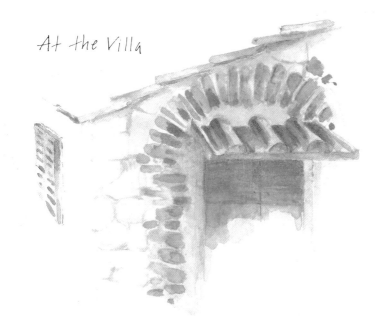

Honey-colored door set
in a twelfth-century wall.

Kindling for the fire is kept
in a gritty, textured tub that
runs to cold blues on the outside
and earth reds on the inside.

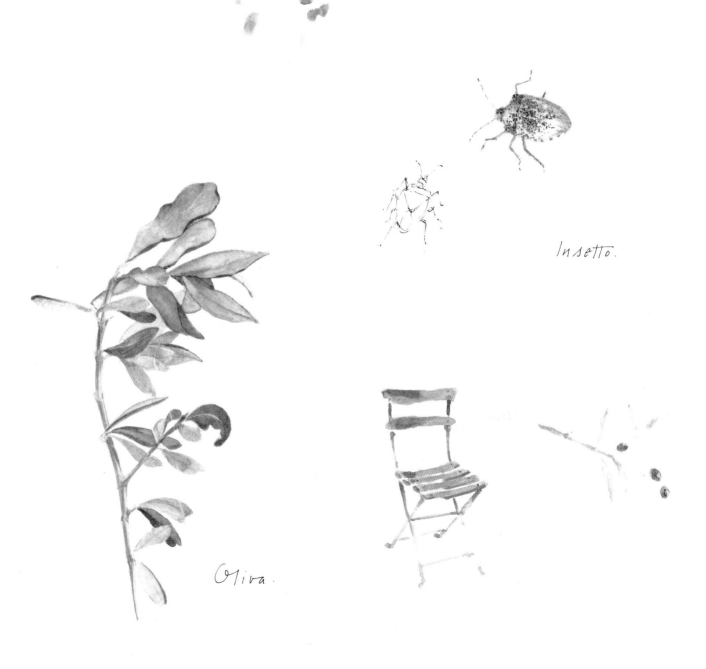

Insetto.

Oliva.

Umbria

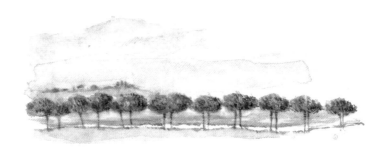

Early Sunday morning. Descending into the plain from
the hills of Cortona, on my way to Florence, I saw a
double line of umbrella pines punctuating the graceful
swells of fields that mark the edge of Tuscany.

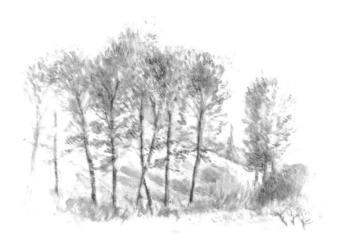

A border of trees that changed dramatically during the day: at first muted and soft, then a solid wall guarding the dense, shadowy wood beyond. They came to life when the sun struck them at the lowest possible angle as it disappeared, and they subsided into a silvery ethereality.

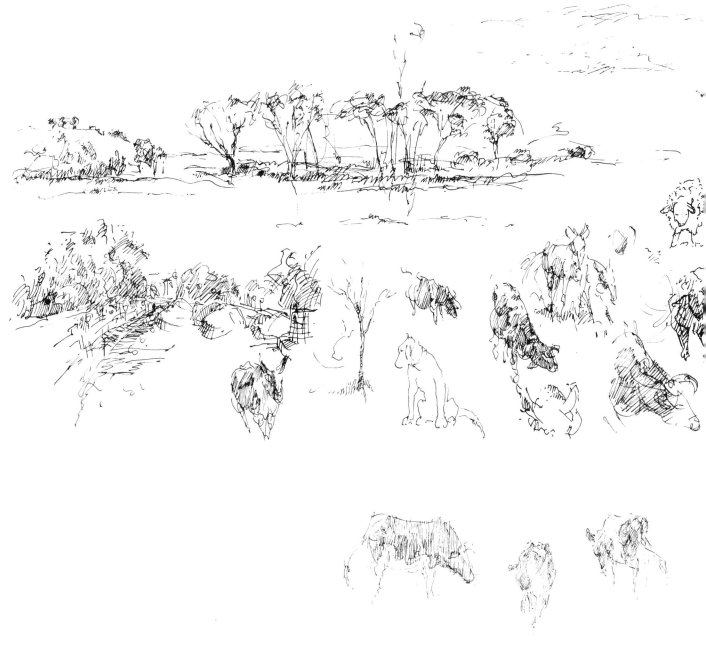

Celebrating a soccer victory.

De rigueur accoutrements:
cigarette and portable phone.

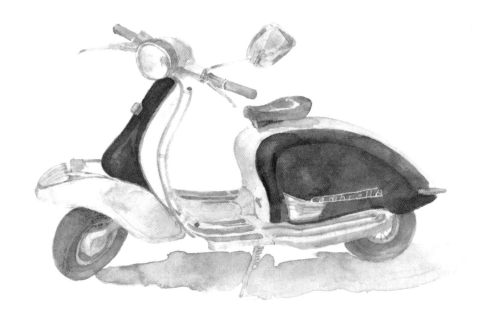

Rome

Driving in Italy is both logical and liberating. It's impossible to get too lost, but it's not always easy to arrive where you want. Because the cars are so small and quick, a certain intimacy and immediacy prevail. Parking is especially inventive.

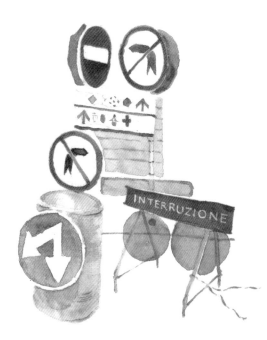

INTERRUZIONE

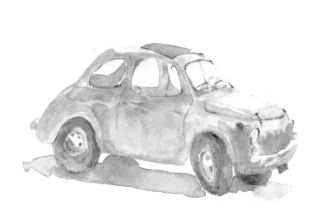

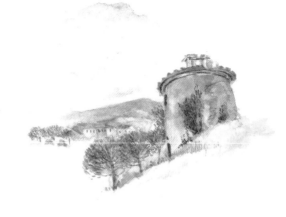

Ginestra

Tobacco-drying barn on
the grounds of Castel
Reschio near Preggio
in Umbria, overlooking
a valley where poppies,
wisteria, and mustard
bloom.

Dusk, Arezzo.

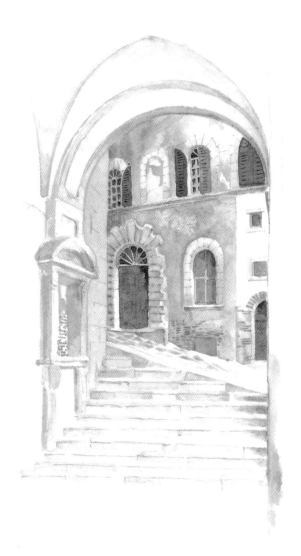

Wallows of pigs
near Lago di Bracciano.

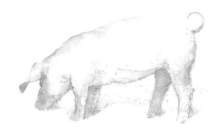

In the country

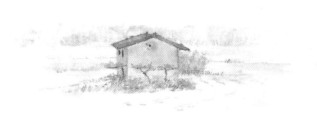

The lingering mist of very
early morning. As it cleared,
the exquisite rhythm of the
landscape was gradually
revealed.

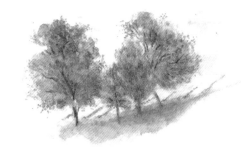

Ostia Antica

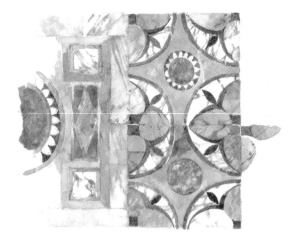

Bitterly cold. Beautiful day though.
Clear brilliant light. No people, the
ruins deserted. No cafe. The frescoed
walls, the mosaic floors, the gracious
proportions of the architecture. In-
tegration of the senses. Attention
to pleasure.

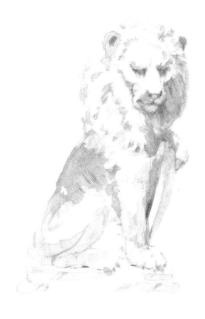

Lion at lunchtime outside Santa
Croce. Such understanding of the
animal and sensitivity to the materials
creates a suspended vitality. Especially
expressive paws.

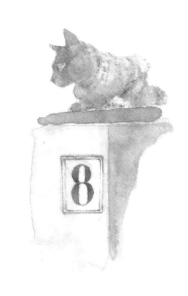

As I painted this view
of a terrace in the country
from memory, big rain
clouds drifted in, then a
downpour. Diagonal dots
and dashes of rain fell hard
on the balcony of my rooftop
studio in Florence.

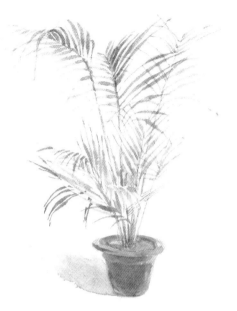

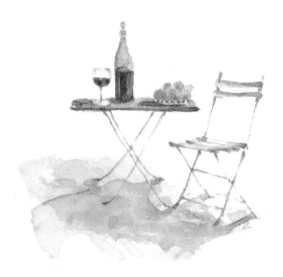

The wine
was homemade.

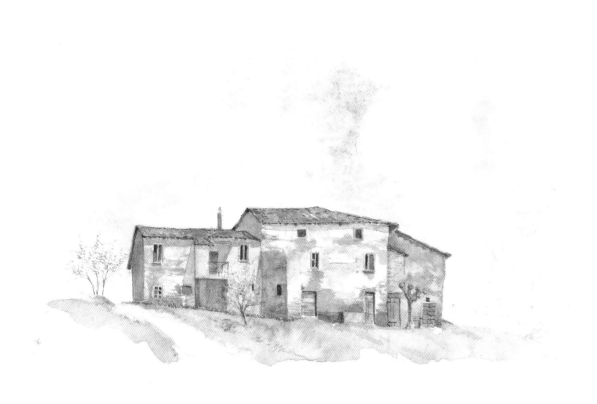

Pale blue house outside Ponticino, by the Arno. Green
doors, olive trees, poppies, and the road white in the sun.

The sunlight shone on the far side of the square,
bleaching the pale ochers to cream.

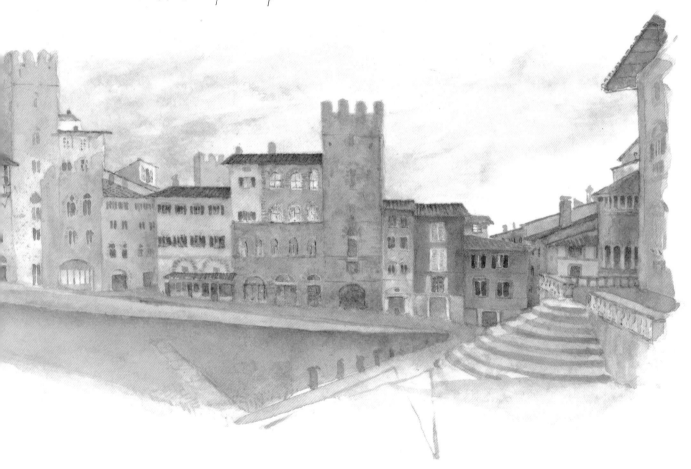

Early evening, Arezzo

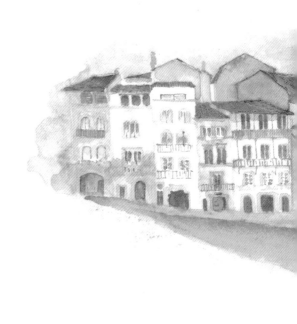

Entering the campo from a dusky alley, the impact of the sudden
expansion of space and the saturation of colored light was dramatic.

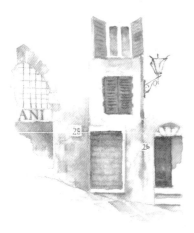

An aluminum door tinted
cerulean blue contrasted with
a door the color of dried blood.
Mossy, mustardy green drips.

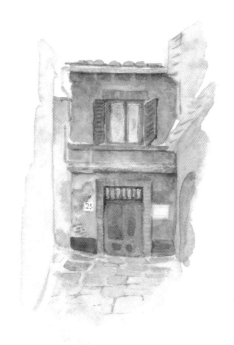

Darkly opalescent glass.

Arezzo

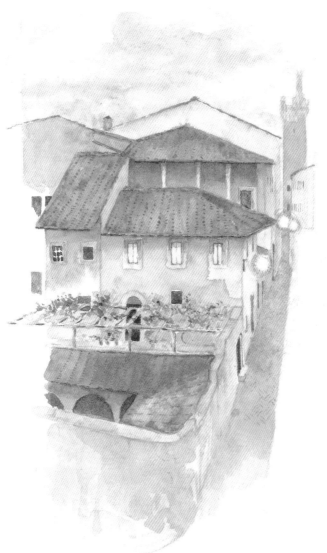

Perspective: looking down from a garden wall into a street rising up. The lights coming on as the sun descends behind pale ultramarine and dull red clouds.

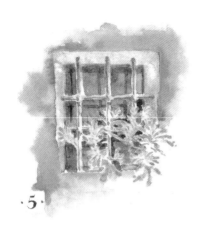

·5·

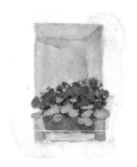

Outrageously hot day. I
walked down the spiral of
stone streets toward the
Campo. Flowers in the cool
shadows of the windows. Bulk
wine delivery. Thirsty.

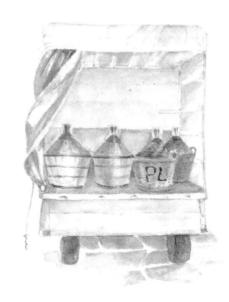

Siena

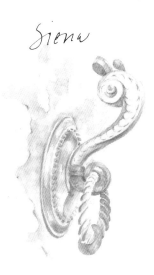

A dark viridian door so
deeply set into the wall and
so narrow at the base that it
reminded me of Egypt All the
colors of the ocean in shadow
shimmered across its surface.

Sconce for torches
outside a sixteenth-
century palazzo.

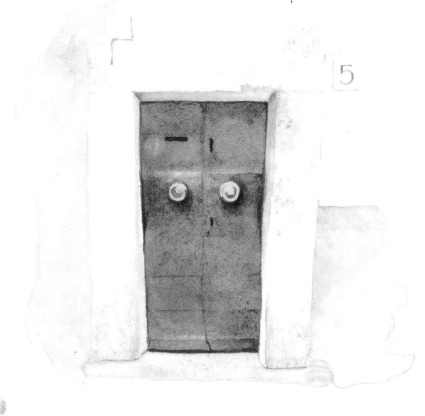

Freestanding ruin of a
doorway with an un-
expectedly intact door.
Burn marks.

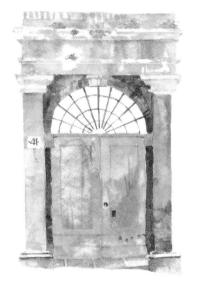

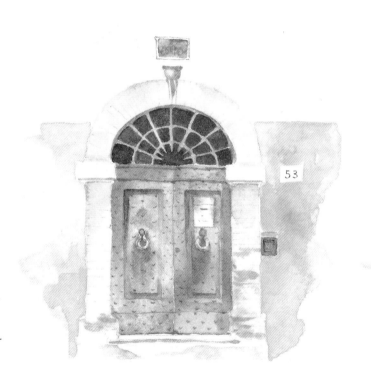

Judicious choice of greens
in a magisterial entry.

Cortona

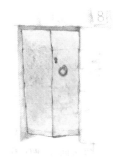

21

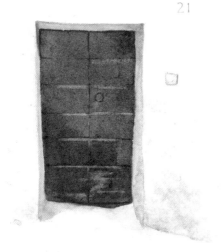

I turned and found
across the way a pale
aquamarine door.

Doorway in a narrow alley,
the rosy blue violet color of
twilight reflecting off the
plastered walls.

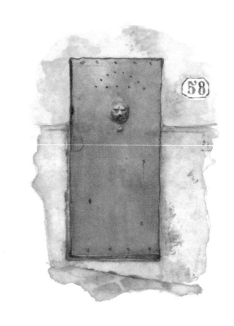

[color notes]
yellow ocher, aureolin, cadmium yellow,
manganese blue, viridian, rose madder,
raw sienna

In an elegant backstreet,
diminutive metal door with
a repoussé lion's head.

Incised numerals.

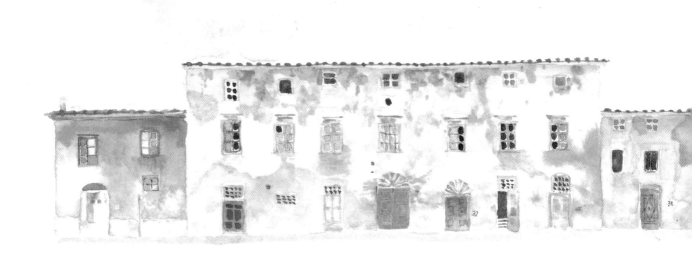

Remarkably crumbling façade in Levanella, patterned like a butterscotch pinto pony. I loved the variety of doors and the range of greens: from aged bitter forest green to bright chartreuse.

PINK OF THE LIGHT ENHANCED AND INTENSIFIED THE PINK OF THE STONE.

IN THE FALL I ARRIVED IN ROME. AT FIRST THE HEAT, THE NOISE, AND THE TRAFFIC WERE OVERPOWERING. THE SUN BLEACHED ALL COLOR AND LEFT THE SKY WHITE. THE LIGHT GLARED AND THE SHADOWS WERE IMPENETRABLE VOIDS. IN THE HAZE IT WAS DIFFICULT TO READ DISTANCE. THE HORIZON WAS A SMUDGE. AND THEN BLUE-PURPLE CLOUDS MASSED AND SWEPT OVER THE CITY. THE RAIN CAME WITH SUCH FORCE IT RICOCHETED OFF THE SIDEWALK, ACCOMPANIED FOR HOURS BY THUNDER AND LIGHTNING. AT LAST COLORS EMERGED IN THEIR TRUE DEPTH AND COMPLEXITY: DULL PLUM, BRONZE OLIVE, GOLD OCHER, AND SALMON PINK. THE REFINEMENT AND SENUOUS ELEGANCE OF SURFACE AND THE SUBTLE AND INTRICATE PLAY OF SPACE WERE CONTINUALLY INSPIRING. A YEAR WAS TOO SHORT TO CONTEMPLATE SUCH VAST BEAUTY, AND ONE BOOK IS NOT ENOUGH TO CAPTURE IT. IN *Road to Rome* I HAVE TRIED TO RECORD THE ESSENCE OF THE DAYS AND NIGHTS, TWILIGHTS AND DAWNS OF TUSCANY AND UMBRIA, BOTH TO CAPTURE MY STAY AND INSPIRE MY RETURN.

BRILLIANT LIGHT. A FRIEND'S VILLA IMMEDIATELY OUTSIDE FLORENCE PROVIDED AN ELEGANT SPOT FOR WORKING. I WAS SURROUNDED BY VINEYARDS AND OLIVE GROVES, AND THE VILLA POSSESSED A GLORIOUS FROG POND WITH A BUILT-IN SWIMMING POOL FOR HUMANS. THERE I FIRST APPRECIATED THE ABUNDANCE, BEAUTY, AND SIZE OF ITALIAN INSECT LIFE.

OTHER FRIENDS HAD RECENTLY RESTORED A *casa colonica* IN UMBRIA, TO THE SOUTH AND EAST THERE I WAS ALSO ABLE TO WORK IN ABSOLUTE PEACE, EXCEPT, OF COURSE, FOR THE CONTINUOUS CALLING OF THE CUCKOO. EVERY MORNING I AWOKE AT SUNRISE AND LOOKED THROUGH THE SMALL WINDOWS SET IN THICK STONE WALLS TO SEE WHAT KIND OF DAY IT WOULD BE, WALKED THROUGH THE COOL DARK FARMHOUSE TO PREPARE A CAFFÈ LATTE, AND OPENED THE BIG FRONT DOUBLE DOORS TO A VIEW THAT EMBRACED AN ENTIRE VALLEY.

THE QUALITY OF LIGHT AND THE HOUR OF THE DAY MADE IMPRESSIONS STRIKING THAT OTHERWISE MIGHT HAVE GONE UNNOTICED. AREZZO WAS ESPECIALLY BEAUTIFUL AROUND 7 P.M. IN THE EARLY SUMMER. CORTONA GLITTERED IN THE LATE MORNING. ASSISI SHONE AT DUSK, WHEN THE

MORNING I PICKED UP MY SKETCHBOOK AND STARTED OUT BY FOOT OR BY CAR WITH NO PLAN, NO INTENTION, BUT TO DRAW.

MY JOURNEY BEGAN IN FLORENCE. AGAIN I ARRIVED IN THE EVENING, DRIVING DOWN FROM MILAN. BY SOME PLANNING - BUT MORE CHANCE - I CAME ACROSS THE STREET ENTRANCE OF MY HOTEL IN THE PEDESTRIAN CENTER. I FOOLISHLY THOUGHT I COULD DRIVE AROUND THE CORNER TO THE GARAGE. *Zona pedonale*, NO ENTRY, AND ONE WAY STREET SIGNS CONSPIRED TO TO DEFEAT MY INTENTION. NO LESS THAN AN HOUR LATER I PULLED INTO THE GARAGE RELIEVED AND EXHAUSTED, AND IMMEDIATELY MANAGED TO DENT THE CAR BY TANGLING WITH A CEMENT PILLAR. ONCE INSIDE, HOWEVER, MY DIFFICULTIES EASED. MY ROOM, FAR FROM BEING THE GARRET I FEARED, HAD FRENCH DOORS THAT OPENED ONTO A LARGE TERRACE. THE MAY NIGHT REVEALED A YELLOW MOON JUST ABOVE THE HORIZON AND A SPRINKLING OF STARS. I WAS READY TO BEGIN.

FLORENCE, DIGNIFIED AND AUSTERE, WAS A CITY OF DOORS AND DOOR KNOCKERS, COUNTRYSIDE LUSH WITH A PROFUSION OF WILDFLOWERS SPARKLING IN THE

INTRODUCTION

I FIRST SAW THE ITALIAN COUNTRYSIDE AT NIGHT WHILE TRAVELING BY TRAIN FROM ROME TO FLORENCE. THE SCENT OF FRESH LEMONS RUSHED INTO THE COMPARTMENT THROUGH AN OPEN WINDOW AS WE CHUGGED AND CLATTERED NORTH. THE BEAUTY OF THE LANDSCAPE WAS APPARENT EVEN IN THE WARM SPRING DARK: THE SCULPTURAL RHYTHM OF THE TALL CYPRESSES, THE LONG LOW VINEYARDS, AND THE HILLS PUNCTUATED BY CLUSTERED LIGHTS FROM SMALL VILLAGES OR SINGLE LIGHTS FROM ISOLATED FARMHOUSES.

THE FULLNESS OF THE DAYS, THE GRACE OF THE ARCHITECTURE, AND THE GLOW OF THE LIGHT, COMPELLED MY RETURN. WITH EACH VISIT MY LOVE OF ITALY GREW. SIMPLY PUT, I LIKED THE LIFE. EVENTUALLY I WAS ABLE TO SPEND AN EXTENDED PERIOD OF TIME WANDERING THROUGH TUSCANY SOUTH TO ROME, THE TRIP THAT WAS THE INSPIRATION FOR THIS JOURNAL. EVERY

Whoever has nothing else left in life should come to live in Rome: there he will find for society a land which will nourish his reflections, walks which will always tell him something new. The stone which crumbles under his feet will speak to him, and even the dust which the wind raises under his footsteps will seem to bear with it something of human grandeur.

FRANÇOIS - RENÉ DE CHATAUBRIAND

Printed in Hong Kong.

ISBN 0-8118-0577-8

Library of Congress Cataloging-in-Publication Data available.

Book design: Brenda Rae Eno and Joyce Kuchar.
Cover design: Kathy Warinner.
Cover Illustration: Marlene McLoughlin

Distributed in Canada by Raincoast Books
8680 Cambie Street Vancouver, B.C. V6P 6M9

10 9 8 7 6 5 4 3 2 1

Chronicle Books
275 Fifth Street
San Francisco, CA 94103

Road to Rome

AN ARTIST'S YEAR IN ITALY

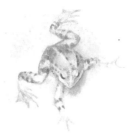

BY MARLENE MCLOUGHLIN

CHRONICLE BOOKS
SAN FRANCISCO